The McGraw-Hill Guide to Electronic Research in Art

Diana Roberts Wienbroer
Nassau Community College

Adapted for art by
William Allen
Arkansas State Univeristy

Boston Burr Ridge, IL Dubuque, IA Madison, WI New York San Francisco St. Louis
Bangkok Bogotá Caracas Lisbon London Madrid
Mexico City Milan New Delhi Seoul Singapore Sydney Taipei Toronto

McGraw-Hill Higher Education

A Division of The McGraw·Hill Companies

1 2 3 4 5 6 7 8 9 0 BKM/BKM 9 0 9 8 7 6 5 4 3 2 1 0 9

ISBN 0-07-232956-4

http://www.mhhe.com

Table of Contents

Preface

This guide is for you if you're new to using the computer for research, or if you're an experienced "hacker" who now has to write a college term paper. Included are suggestions for using the power of computers to ease our research and the reporting of it.

You will succeed if you understand the nature of electronic research before you begin. Take some time now to skim over the various headings in each chapter. Read Chapters 1 and 2 before turning to the computer so your time (and often your money) will not be wasted. By design, there are portions you may be able to skip or quickly skim. Key terms appear in **boldface**.

Once you begin your research, keep this guide handy while you are working at the computer. Internet addresses are listed at the end of the book, and tips on various services are included in Chapter 3. Chapter 4 should help with organizing your research materials—whether they be digital images or straight text. When you're finally ready to write your report, use Chapter 5 to supplement any directions your teacher has given you.

This book is not a comprehensive guide to the Internet. For detailed coverage, see Every Student's Guide to the Internet by Keiko Pitter et al (New York: McGraw-Hill, 1998).

We hope that you find this guide useful. All Internet addresses are current as of August 1999. If you have any questions, comments, or suggestions for revision, please email or write us:

art@mcgraw-hill.com

McGraw-Hill College Division
Art & Humanities
2 Penn Plaza, 20th Floor
New York, NY 10121

What You Need to Know Before You Start

It's exciting and easy to search for information using computers—often to the point that it doesn't feel like work at all. However, it can also be frustrating and time consuming if you don't know what to expect. If you're new to computers—or if you're familiar with only one system—read this chapter before you start.

Information is available via computer in several ways:

- From home if you have an encyclopedia or other resource on CD-ROM, or have access to the Internet
- At a library where you can consult the catalog as well as other databases installed in designated computers; you may also have Internet access at designated computers
- At a college computer lab with Internet access
- At a commercial outlet (perhaps called "Internet Cafe" or "Cyberhouse") where you can use computers for an hourly fee—check the Yellow Pages of your local directory under "Computer Rental" or "Computer Training." These places ordinarily have technical advisers, and may offer classes in using the Internet.

Note that even though the outlet may offer access to online commercial services, you can't use one without your own established personal account.

▼ Definitions: Some key terms

A **CD-ROM** is a disk that looks just like an audio CD, but it contains computer programs or data—often the equivalent of whole shelves of books or periodicals. CD-ROM versions of encyclopedias, dictionaries, atlases, and other reference works are available in libraries and also for consumer purchase. Sometimes you are connecting to a CD-ROM on the Internet. *ROM* means "Read Only Memory" since the data on a CD-ROM is fixed (can't be changed), unlike the fluidity of information you encounter online.

Online is the term for being connected to another computer. You are not online when you are using a non-networked computer for reading a CD-ROM or word processing. The term *online* means that the computer you are using is communicating with another computer, for example, to connect to the Internet, or to access a library's regularly updated catalog and other resources.

The **Internet** is the name given to the network of all the computers in the world that can communicate with each other. The major means of communication on the Internet are e-mail, telnet, FTP, Gopher, Newsgroups, and the World Wide Web.

Some of the computers on the Internet contain huge storehouses of information organized for easy public retrieval. Others (such as a university mainframe computer or American Online) provide the interconnections for networks of personal computers. Still other computers on the Internet provide information from businesses, government agencies, or nonprofit organizations. Connecting to the Internet allows you access to libraries and museums, computer software, elaborate graphics, and ads for products you may or may not want. Further, you can reach thoughtful and generous people who will respond to your questions or entertain you. Unfortunately, you may also encounter people who give misinformation or waste your time.

Via the Internet, you have access to all these resources—almost all of them for free. The challenge is to figure out which ones you want to connect to and how to do so efficiently. Once connected, you'll find some of the information presented in simple text format (plain black typeface on an unadorned screen), but you'll also find some valuable information festooned with colorful and entertaining artwork (including commercials), sound effects, video, and music.

Occasionally, you'll be asked to **register**—giving your name, address, and e-mail address. You will be told if fees are involved, but sometimes registration alone is necessary before you can read the information at that location.

The fastest growing area of the Internet is that of the **World Wide Web (WWW).** This is the name for the **interlinked** part of the Internet where you can, with one keystroke, jump from one topic—and location—to another. As you scroll through the text, you encounter underlined and colored words or phrases; when you click your mouse (or press the Enter/Return key) on that phrase, you jump to a different page relevant to that topic.

Websites (locations on the World Wide Web) use this same linking method. Multimedia Websites also include audio (giving, for example, the pronunciation of a word) or video (a film clip). You might start looking at the **home page** (the first page of a Website) of the National Register of Historic Places at the U.S. Department of the Interior; then you might jump from there to a list of landmarked buildings; next you could see a picture of a specific building—all with just three clicks of the mouse! Later, you might wonder how you got there, but the computer program allows you to go back to each previous screen, where each of the phrases you clicked on (**links**) will have changed color, so you can almost always retrace your path to the beginning of your journey.

Another way people use the Internet is to send **e-mail** (electronic mail). This is the method of sending messages via computer, either to one person or to a group of people, once you know the correct Internet address. Computers make it possible to send copies simultaneously to a great many people, allowing for "live chats," where individuals type messages back and forth—and many others can read those messages, either at that time or later.

The most important characteristic of the Internet and more specifically the World Wide Web is openness: Anyone with the equipment and know-how can have a WWW page, and anyone else can read that page. Consequently, the Internet is accessible, democratic—and disorganized. Computers speed up access to information, but you can't predict what you will find. You may follow a promising lead and find notes from a scholarly seminar on your topic—or just as easily find someone's family portrait or rambling travelogue. Thus you need to be prepared to spend time searching for what you want.

Download is the term for copying a document from the Internet to your disk or the hard drive of your computer. We speak of computers as **loading** data from a disk or another computer. Thus a Webpage is loading onto your computer as it gradually comes into view. The computer where the Website is located (its **server**) is **uploading** the **Webpages** to you. Should you choose to save them, you would then download copies of those pages onto your own disk.

Note: Some college programs or libraries restrict the types of downloads you are allowed to do. You may be able to copy to your disk or print copies of the screens you are viewing, but you might not. You may also be restricted from downloading from commercial services, where fees could be involved. Be sure to ask where you are using the Internet what rules apply.

Be careful: If you do decide to download for a fee, make sure that your credit card number will be encrypted (scrambled). If it is not, you will be warned that you are about to submit an "insecure" document. If that is the case, others would be able to read your number. By law, a telephone number must be given so that you can phone in your order.

If you have a sizable research project, you will want to save as much information as possible onto your disk (to avoid needless typing). Thus, when you go to the library or computer lab, plan to take several 3.5" disks formatted for the system used there (Mac or PC). Then give a separate name to each document you copy to your disk, so you can find it later.

Browse is the term for moving from one Website to another. Special software, a Web **browser** (such as Netscape or Microsoft's Internet Explorer), makes it possible for you to reach a Website by typing in its address or clicking on a highlighted phrase in a Web page. Time spent visiting a number of Websites is also called **surfing**—a good metaphor for the rapid movement that is possible on the Web.

 ## Connecting to the Internet

Connecting to the Internet is becoming easier and easier. Most libraries (community, public school, college and university) have

computers that permit users to connect to the Internet. Internet kiosks, where you use a credit card to have an access fee billed to you, are appearing in airports, malls, and other public places. Many hotels and motels now make it easy to connect from one's room to the Internet, either via one's laptop or by computer rental from the establishment. It is now rare to find a business office without at least one computer connected to the Internet. Most colleges and universities are routinely wiring dorm rooms for Internet access. Bill Gates recently predicted that by 2001 sixty percent of all US homes will own a PC and that eighty-five percent of those will be connected to the Internet.

Regardless of where you connect to the Internet, the computer you use is communicating (via modem or hard wire) with a powerful computer (the server) that is in turn connected to the Internet. From your personal computer or campus workstation, you use computer software that communicates with the server computer. (Ordinarily, that software is provided when you get an Internet account at home—either with your college or with a commercial service). Other software programs in the server allow you to use e-mail (electronic mail), browse the Web, or download files from the Internet to your disk. Because you are dealing with a computer between you and the Internet, high usage may tax the system you are using; depending on how powerful the system is, you may have occasional or even frequent slowdowns—particularly at term paper times!

Equipment needed to connect to the Internet

If you want to use the Internet from home, you will need:

- a computer with at least 16 megabytes of memory (32 is better)
- a modem (at least 33,600 speed) plus communications software to use it
- a phone line (or a hard wire connection if your college provides it)
- additional software depending on what your Internet server requires

Optional equipment recommended for the World Wide Web includes:

- a color monitor (for dealing with art, get as high resolution a monitor as you can afford)
- a sound card (already built into the Macintosh) and multimedia software for use of multimedia sources

▼ Internet accounts: Username and password

When you open an Internet account—either with your college or with a commercial online service—you will be asked to submit a **username** and **password** so you can logon and receive e-mail. The username (**ID** or **userid**) plus your server's address will be your **e-mail address** on the Internet (usually *username@server address*, such as johnj@aol.com). Sometimes you won't get your first choice of username because someone else is already using it, or because your server assigns usernames by an established system.

Your password is the sequence of letters or numbers (or a combination of letters and numbers) that you type in to gain access to your account. Since you'll be using it often, select a password that is easy to remember and quick to type—and one that others won't be likely to guess. Be sure to type both your username and password carefully during the initial setup (because what you type is the only sequence the computer will recognize ever after) and write both down in a safe location (not in your computer files).

▼ Figuring out Internet addresses

The **Internet address** (sequence of letters and numbers you type to send e-mail or to reach another computer on the Internet) is based on

an established system, DNS (Domain Name System). The last three digits designate the type of institution at the Internet address:

.edu is used by educational institutions
.org is used by nonprofit organizations
.gov is used by governmental agencies
.mil is used by the military
.com is used by commercial organizations
.net is used by large computer networks

These addresses assume that the site is in the United States. In addition, you may encounter addresses that end in a two-letter country code. Here are a few:

.at	Austria	.gr	Greece
.au	Australia	.il	Israel
.br	Brazil	.it	Italy
.ca	Canada	.jp	Japan
.ch	Switzerland	.kr	Korea
.de	Germany	.mx	Mexico
.es	Spain	.uk	United Kingdom
.fr	France	.us	United States

You can often figure out an unknown address by trying possible usernames with the proper suffix. For example, you can accurately deduce how to send an e-mail message on the Internet to the President of the United States:

president@whitehouse.gov

In addition, all the people in your system share the same address, so you can send messages to them once you know (or figure out) their usernames.

Besides using the Internet for e-mail, you will want to visit Websites. You reach sites on the World Wide Web by typing their addresses called **URLs** (universal resource locators), usually starting with http://www. See pages 57–59 for some important addresses, including directories to the Internet.

You can also figure out some addresses for World Wide Web sites. Try a simple name with the appropriate prefix and suffix. For example, you can reach these Websites by typing their fairly obvious addresses:

New York Times	http://www.nytimes.com
Wall Street Journal	http://www.wsj.com
Metropolitan Museum	http://www.metmuseum.com
Louvre museum in France	http://www.louvre.fr
College Art Association	http://www.collegeart.org

Be careful: When typing, you must use the exact sequence of letters and punctuation of the address. Unlike a wrong number on the telephone, you won't know if our e-mail message reached the wrong person on the Internet. If you get a reply "wrong DNS" or unknown URL," check your typing first; if the spelling is correct, try one of the directories listed on pages 57–59. Be aware, however, that one of the most important characteristics of the Internet is its rapid rate of change. Most sites that move leave a forwarding address, but some do not.

 Getting around within different programs

Even if you've used a computer for word processing, you may encounter computer systems where your actions will not bring about the expected results. Regardless of the program you're using on your own computer, you will be restricted to the format of the program you're communicating with on the Internet.

Maneuvering with keyboard or mouse

Selecting

Often you will tell the computer what you want by choosing from a **menu** (list) of options, or by **selecting** an underlined phrase presented in a different color from the rest of the text. You communicate your selection by clicking the mouse or by pressing Enter/Return after the choice is highlighted. Note that a phrase can't be selected until the cursor is positioned *exactly* on the phrase. With many programs, the

cursor changes from an arrow to a hand pointing upward to indicate that you can select at that point.

Scrolling

Whether using a keyboard or mouse-based system, you **scroll** down (move vertically down through the text) as you read the material on the screen. For scrolling, you can use the arrow keys, the Page Up or Page Down keys, or the mouse. To use the mouse, look at the right edge of the screen. You will notice a vertical border for the window you are working in. If there are two borders, the one on the inner frame controls the window you're working in. You either position the cursor and click continuously on an arrow pointing in the direction you want to move the text (up or down), or you may click on a square "button" to slide it down the margin as you read. Just click and hold the mouse button down as you guide the mouse smoothly and in a straight line (towards you to go down; away from you to go up). This method is particularly useful if you want to skim a document quickly.

You won't be able to scroll through or save a document while it is loading. Programs usually provide a visual clue to the status of downloading—for example, a horizontal bar graph, a thermometer, shooting stars (Netscape), or a spinning pyramid (America Online). *Note*: The position of the square "button" in the right margin is also a clue to the length of the material you are reading, since most of the time the pages aren't numbered. It will be at the top at the beginning of the document and all the way at the bottom at the end.

Saving

In nearly every program, the top of the screen will have a section labeled Options or Commands. Mouse-click (or arrow and press Enter/Return) to read a menu of choices. **Save** or **Record** will allow you to save the data in the file on your current screen (which you can then read more carefully and extract specific notes from) and may even give an appropriate footnote.

Insert your formatted disk into the computer (unless you are saving to your hard drive). Be sure to name each file with a different name, and write down the full title and Internet address (you can't enter any of your own writing directly on this file yet).

Note: Only the file you're actually reading will be saved, not any of the linked files. If you want to save them also, you have to get each file on the screen and save each one separately.

If you are working in a library or computer lab, be sure to save your notes in test-only format, both to save space and to make sure that your word processing program can read them. Some libraries or computer labs may not allow you to save on your own disk. If not, see whether you can print the files you want.

Other options

The headings in each program vary, but there are usually a number of useful options listed on the top of the screen. If you highlight them, there will either be an explanation or a drop-down menu. Just mouse-click on the heading. Then, while holding the mouse button down, drag down to highlight your choice and release the mouse. See page 60 for definitions of the **Bookmark, Reload, Forward, Back, Stop,** and **History** buttons.

Error messages

Many programs will alert you with a sound effect if you're trying to perform something that won't work. Others will give an error message. You can usually click on **Help** to learn what to do.

Exiting

As you enter a program, often there will be a line at the beginning telling you how to exit or quit. Note that command (frequently Alt + F4). If you forget, you can usually type Q or mouse-click in the top-right or top-left corner where you'll see an X or square. **Don't just turn off your computer**—particularly if you're connected to a text-based host computer program. It can leave that computer line busy and leave the computer in a temporarily unusable condition for others.

Preparing for Your Research

Using computers to find information sounds easy, and often it is. However, you will also have access to much more material than you could ever read, and the information you need may be buried under a lot of stuff you don't care about. Researching with computers can be successful only when you understand how the information is organized, as well as what computers can and cannot do.

▼ What computers can and cannot do

Whether you are searching on CD-ROM or on the Internet, **search tools** (computer programs that locate sources of information) will ask you for a subject area or for search terms (keywords). Researching programs are user friendly, so you'll often get plenty of information quickly. However, you still need to be creative in how you tell the computer what to look for.

What Computers Can Do	*What You Must Do*
Scan a vast number of documents rapidly	Determine the best words to use for scanning the documents
Organize the results	Indicate your priorities
Respond to your specific limits	Articulate those limits
Allow you to download files to use in your report	Save the files on your disk; record bibliographic information

What Computers Cannot Do	*What You Must Do*
Find something wrapped inside something else	Use synonyms; suggest more general topics; be creative in phrasing your search
Find something that isn't there	Recognize that some material isn't available electronically; understand how files are stored; carefully select the databases you search
Correct a misspelled word	Proofread zealously; use alternate spelling when appropriate; recognize that typos occur in indexes and catalogs
Discriminate between different meanings, such as Mercury the car or planet and mercury the mineral	Add words preceded by "not" so you eliminate unwanted usage of your search term
Provide context	Add terms that provide context, such as "toxic mercury" "Northern Italian Renaissance painting"

▼ Understanding where the information is

Although computers have revolutionized the way libraries work, the basic method of organizing resources remains the same as that of the old print-based days: Librarians catalog books, magazines, newspapers, photographs, and recordings by author, title, and subject, with cross-references to important subtopics within the subject. This information is stored in the library's **catalog**, so you can look for a work by subject—or by author or title if you have that information. Articles in magazines and newspapers are listed in **indexes** according to this same method. Computer programs can rapidly scan catalogs and indexes—even pages of articles or the tables of contents and indexes of individual books—for words you specify. Some programs also look for related subtopics that you haven't even mentioned. In addition, electronic databases can sometimes give you the text itself to read on the screen or to print out.

Databases

Academic research papers require information found in articles published in scholarly periodicals, many of which are not on the Web. Therefore, you will need to consult some **specialized databases** that index scholarly articles. There are four types of specialized databases: bibliographic and full-text databases, statistical sources, and directories. Your library will have a number of these installed in designated computers for you to consult.

Bibliographic databases (lists of titles of books and articles) are the most common type of database. These indexes and catalogs will usually give you a brief description or the abstract of a book or article, along with the title, author, publisher, date of publication, and number of pages.

In the library, you will have access not only to its catalog but also to a variety of indexes on CD-ROM, installed at designated computers. You can find out which periodicals the library subscribes to in the catalog, but to find specific articles, you will need to consult indexes. For example, you can find general interest magazines and newspapers indexed in the *Magazine Index* or the *Readers Guide*.

Journals in art history are covered by *Art Abstracts, Humanities Abstracts, ARTbibliographies Modern, Bibliography of the History of Art,* and the *Avery Index to Architectural Periodicals*. Some of these indexes are available for limited searching at the Getty Information Institute http://www.gii.getty.edu/ (click on "Research Databases").

One of the most useful indexes is the Arts and Humanities Citation Index. A citation index literally indexes footnotes and bibliographies from scholarly journals. Let's say that you are doing a paper on iconography in early Flemish Renaissance painting and one of the most useful items you have found so far is Erwin Panofsky's *Early Netherlandish Painting*. The book is also quite old, first published in 1953. By looking up the author and title in a citation index, you can find pointers to people who have written more recently and made reference to the Panofsky title. The print version of the A&HCI covers publications back to 1975 while the online version goes back to 1982.

After finding the titles of books and articles you want to read, you'll then have to find them in the library. The database will often tell you the location of the book or article—whether it's in the reference section, on reserve, on microfilm or microfiche.

Full-text databases include the whole text, not just the title. Understandably, there are not very many of these, and they usually present only sources from the last few years. Most of these indexes provide unformatted texts for recent articles, but the Bartleby and Gutenberg projects on the Web have scanned entire books in beautiful format. If you want, you can read these books on the screen. On the Internet, some full-text databases require a fee for you to see the actual text. However, selected recent articles are available free from *American Art* http://nmaa-ryder.si.edu/journal/homeframe.html, *The New York Times* Arts/Living section http://www.nytimes.com/yr/mo/day/artleisure/, and *Leonardo*, a publication of the International Society for the Arts, Sciences and Technology (ISAST) http://mitpress.mit.edu/e-journals/Leonardo/home.html. The College Art Association regularly reviews scholarly art history books at CAA.Reviews http://www.caareviews.org/contents.html. Jeffery Howe of Boston College maintains a website of art history related journals that either have online editions or publish excerpts from their printed editions. Howe's website can be found at http://www.bc.edu/bc_org/avp/cas/fnart/links/artjournals.html.

▼ The Internet

In addition to the library with its books, journals, and electronic databases, you have the entire Internet (see p. 2) to explore. Since 1987, people all over the world, usually as part of their jobs or schoolwork, have been scanning in titles, summaries, and even entire copies of articles and books, creating lists of resources, writing informative studies—and putting the results up on the World Wide Web for everyone to freely use. (See, for example, an e-version of the "The Literature of Art," by the late E.H. Gombrich, on the Yale University Library website, http://www.library.yale.edu/art/ ehgkl1.html). Particularly important in the development of stronger and stronger art history resources on the WWW have been some of the world's great museums. A leader in this regard is Washington's National Gallery of Art, http://www.nga.gov, where good-quality reproductions of works, often with excellent details, are accompanied by well-written essays or excerpts from museum catalogues. Another leader is the consortium, Fine Arts Museums of San Francisco, http://www.famsf.org/, led by the DeYoung and the Legion of Honor museums who have boldly committed to putting digital images of 100 percent of their holdings online. Institutions that were long hesitant to put quality digital images on the web are relenting and we are certain to see more and more of these collections made available on the Internet.

▼ Expect to use printed sources

Most books and articles are not available online. You will still need to go to the library to read them and take notes. And you may prefer to read printed sources even when they are also available on computer.

- Most electronic texts of articles are devoid of formatting. You get just plain typeface—often many screenfuls—that you have to search carefully to find what you want. Formatting in print, on the other hand, makes it easy to skim material. You can

read selected passages in a long article, noting headings, illustrations, and first and last paragraphs.

- You can browse in print, flipping through the table of contents or index of a book, for example, or sampling a middle chapter.
- It may be faster to find the print version. For example, even when you know that a particular article was on the front page of last Sunday's *New York Times*, you won't find the article nearly so fast electronically as you will if you just go to the library and pick up the paper, because only selected articles of the *New York Times* appear online, and what's available isn't indexed by page number.
- Text-only electronic versions of articles are taken out of the context of the original. Graphics, other articles, and advertisements adjacent to an article in a newspaper or journal can give you a broader sense of history and culture.
- You can immediately tell the size of a book or article in print, but it's difficult to get a sense of the length of some computerized texts. You won't necessarily know even when the size of the file is given (for example, 15K) because some of those kilobytes may be for graphics. (Without graphics, 15K is about 6 pages.) If the information is given, note the pages an article covered in its original form.

General guidelines for a research project

The same guidelines for searching through print apply to researching electronically:

- Spend preliminary time jotting down ideas and questions.
- Determine the level of information you need and the time limits of your project.
- Continually refine your search as you go.
- Save notes on your computer disk when possible.
- Record the source of every fact or quotation.
- Stop periodically to assess your progress and write your thoughts on what you are discovering.

- Stay open to discovery, allowing time for browsing and reflection.

For example, if your topic is Ancient Greek Architecture, first figure out what it is you want to learn more about. Are you interested in a specific site in Greece? in methods of construction? in the religious implications of temple design? or perhaps in the evolution of Greek architectural ideas as they spread in the Hellenistic and Roman worlds? If you're new to the topic, you may want to read an article in an art or architectural encyclopedia to get some background. Make a list of questions and then extract the keywords or terms you'll need to look for. Have a significant list of keywords and their synonyms handy when you turn to the keyboard.

In addition, list associated subject areas where you might find information (geography, geology, political and military history, economics, engineering, the history of construction, etc.). Even tourist agencies and national ministries of commerce, while not likely to offer much scholarly material, might be good sources of images. Later, when we talk about doing Internet searching, we'll see that following up on even doubtful leads need not cost much in time and effort.

If you know a great deal about your topic, write a brief summary for yourself. Put what you already know into perspective. Identify areas that are only faintly familiar as possible areas for follow-up. You might know quite a lot about Greek construction methods but little about Greek city planning. Perhaps, then, your research ought to take you in the direction of planning so that you broaden your expertise.

If you have a vague idea of what you want to find, or a small point you need an answer for, you may need to discuss your project with a librarian or your teacher, or even put a question to a newsgroup on the Internet (see page 34).

Often it will be difficult to plan your project, or to know what direction it will take, until you do some exploring. One of the secrets of success in doing college-level research is starting early so that you have the luxury of time to explore and investigate. Remain aware of the assignment and your own level of expertise. What **level of information** do you need? A 20-page paper needs much more detailed information and analysis than a 5-page one. A paper on Greek architecture will be much more complex for a class in Greek art history than for Art Appreciation 101.

▼ ## Time management

If you will be connecting to the Internet from home, don't forget to **allow time to use the library** where you'll need to consult print sources—and perhaps get a librarian's help.

With electronic research, you'll quickly get a great deal of information. Be sure to have a plan so you have time to **analyze** the researched material. Stop periodically to assess both the emerging general picture you have of your topic and the quality of the specific information. Researching electronically can become a mesmerizing activity, and you might find that at the end of a pleasant afternoon there is nothing to report. You might even try setting a timer (some computers have this feature installed), stopping every hour or so to make sure you have something concrete, so you aren't caught empty-handed at the deadline.

In libraries, you may be restricted to fifteen minutes' usage of a computer during peak times. If you're using a commercial service, you can easily run up a huge bill. Here are some tips to most effectively use your time online:

- Narrow your search and have a good list of search words before you go online.
- Use the **helpline** (look for a button with a question mark or for Help or Search for Help), particularly when you use an program for the first time.
- Use **keywords** and the **Back** button; **bookmark** favorite sites (see the inside front cover).
- As you come across interesting information, save it to your disk and then read and/or print offline.
- Compose and read e-mail offline (your program will show you how).
- If a site takes too long to come up, use the Stop button at the top of the screen (or Ctrl + Pause, or Esc) to interrupt the request. Then make a note of it and try again later.
- If your computer offers sufficient power, have it opening several browser windows at the same time (if you right-click on a link you have the option of opening the link in a new

window). This can be especially helpful when you have a page of perhaps-useful search engine returns.

On the other hand, **recognize the value of browsing.** Allow time (say in half an hour) for aimless exploring. Since the Web is constantly changing, give yourself the chance to be open to new discoveries. If you feel overwhelmed or frustrated, stop to recall what you asked the computer to do. You may have asked the wrong question, or the answer you expect is not as readily available as you hoped. You need not be intimidated by the wealth of information on the Internet. You can, with patience, usually find ways to discover what you want to know.

A WORD ABOUT INTERNET COURTESY

Although the Internet often feels huge and impersonal, your behavior will affect other human beings. There are a few ground rules based on the spirit of the Internet.

- Communication between computers means you're using the time and energy (**bandwidth**) of other computers whenever you logon or connect to a Website. Don't tax the system by carelessly typing addresses; surfing areas you have no interest in; failing to logoff properly; or using a foreign site when a domestic one is available. When possible, download at offpeak times; when a site gives you the option, choosing to download at a high "niceness level" creates the least amount of site slowdown for other users.
- Honor the time limits on a library computer during peak usage. Empty your e-mail regularly. Cancel subscriptions to Listservs and Usent groups when your interest has waned.
- When visiting a newsgroup, read the FAQs (list of Frequently Asked/Answered Questions) first; then "lurk" for several days to learn the acceptable behavior for that group before commenting. This way, you'll get a sense of the intellectual level of the conversation, the philosophy of the majority of users, and the treatment of newcomers.
- You may have heard of "flaming"—an abusive or sarcastic response to a posting on the Internet. Some groups accept and even encourage such a tone, but many do not. It's best to be sure which group you're in.

CHAPTER **3**

Conducting Your Research

Before you begin your research, you'll need a clear idea of what you want to discover. You may want just to browse first—either in your library or on the Internet. If you begin with a general subject, you may get plenty of information from whatever turns up first. By taking time to narrow your search you might get more specific information (closer to what you really want). In any case, you'll need some words to type in to tell the computer what you're looking for.

 Searching in your library

Chances are that your library has electronic resources. At the very least you can expect to have the library's own book holdings available in an "electronic card catalogue." Most likely, your library also has at least a few specialized databases available on CD-ROM or by license over the Internet. Of course, you may be lucky and be at a school that has vast electronic resources (including some that it produces itself). But no matter what level of electronic progress your library has made, it is always the best place to begin a research project.

One excellent reason for beginning your search in your own library is that you will have human help if you need it. Most of today's librarians have experience working with both CD-ROM databases held

within the library and in searching for material on the Internet. Many libraries offer quick courses on a regular basis on using electronic resources in research. Take advantage of whatever help your library offers.

Many of your research resources are going to be print resources—books and journals. You will impress your own reference librarian if you can demonstrate that you have already made an attempt to locate information locally and now need more help either with local holdings or with holdings elsewhere. Chances are that as you accumulate a list of printed titles that you want to see, some of these will not be available in your library. However, all libraries have some kind of cooperative arrangement with other libraries for "Inter-Library-Loans." Be sure to find out where your ILL desk or office is located and find out the procedures for requesting ILL services. Another good reason for getting an early start on our research is that once you have titles that you want your ILL service to procure for you, it may take days or even weeks for the material to reach your library from wherever they borrow it. ILL services are not much help if your paper is due in three days!

If your library has a good store of electronic databases that lead to journal articles then you will want to take full advantage of this service. If your institution does not have access to journal article databases, there is one web source that might help: UnCoverWeb (formerly known as CARL UnCover), http://uncweb.carl.org/ You may search the site by title or by subject and UnCoverWeb will return items that match your terms. The database is growing at UnCoverWeb so the usefulness of this site will increase with time. Searching is free; for a fee you can have the company fax or mail a photocopy of most articles to you. Full details on this service are on the website (but, if you do find an item of interest, double check that your library does not own the journal before you pay to have a copy sent to you).

Searching in libraries elsewhere

Just as you find book titles in your own library's electronic card catalogue, you can find titles by searching the electronic card catalogues of other libraries. Several universities and other institutions

make their catalogues available over the Internet. You will not be able to borrow directly over the Internet, but when you find a likely-looking title elsewhere, take down all of the bibliographic information and submit this information to your ILL office.

Libraries with online catalogues available to the public often have excellent search facilities (by author, title, subject, etc.). In addition, many also have a mechanism in which you can mark items of interest and request the system to e-mail the bibliographic information to you. When you visit a library elsewhere, carefully read the introductory material so that you know how to use the system. Among libraries with excellent holdings in art history and with public access to their catalogue are:

New York University, http://www.nyu.edu/library/ (BobCat is a
 Telnet connection, BobCatPlus is a web-based connection)
Harvard university, http://hplus.harvard.edu/ (choose Hollis
 Library)
Boston University, http://web.bu.edu/library/ (Internet connection
 is via Telnet; note that when you enter you have a choice
 between the University's online catalogue and the Boston
 Library Consortium Union List of Serials. The latter is an
 excellent place to get at least **titles of journals** that may yield
 useful material).
University of California System, http://www.dla.ucop.edu/
 welcome.html
The Library of Congress, http://lcweb.loc.gov/homepage/ (There
 are vast resources here, including direct Internet access to
 images, movies, and sound recordings. However, you will
 need to read the introductory material carefully in order to
 ascertain how to get what you want).
University of Toronto, http://www.library.utoronto.ca/ (chose
 UTCat)
The British Library, http://www.bl.uk/
The National Art Library of the Victoria and Albert Museum,
 http://www.nal.vam.ac.uk/nalcomct.html
Bodleian and other Oxford Libraries,
 http://www.bodley.ox.ac.uk/oxlip/bobcat.htm
Bibliothèque Nationale, France, http://www.bnf.fr/ (English:
 http://www.bnf.fr/bnfgb.htm) is at the time of this writing still
 "buggy," but promises to be a wonderful resource when the

problems are fixed. It will eventually let you tap into any library in France! Check on it from time to time.

Please note that some library connections, especially those via Telnet, request that you "sign off" or "exit" when you are finished with your search. **This is an important courtesy** since libraries can accommodate only a limited number of visitors at a time and if you leave without telling the system that you are leaving, your connection will remain open until it "times out."

▼ Beginning the search

A good place to begin is with an encyclopedia. For example, *Encyclopedia Britannica* is available online or may be installed in computers in your library. Your library might even have access to something like The Grove Dictionary of Art online. Alternatively, an encyclopedia may be part of your word processing program or in the reference section of your online service.

Start with a broad topic heading: *Greek architecture*. Microsoft's *Bookshelf '98* gives an entry, *Greek architecture and art* which offers a brief chronological survey of the major developments of Greek architecture from the Geometric through the Hellenistic periods. Some key terms (for example, *column, temple,* and *mural painting*) are highlighted as links to other articles in the CD-ROM. Listed beneath the main topic are references to some specific Greek buildings as well as ancillary topics such as *Greek Revival*. Jot down terms that look promising for use as you expand your search to other electronic resources. Like other modern CD-ROM reference works, *Bookshelf '98* also lets you launch your keywords as searches on *Encarta Online* and on an Internet search engine.

Even though nothing that you find in such a general reference work (whether it be on CD-ROM or a hardbound "desk encyclopedia") is likely to find its way into your final research, you will have spent very little time and accumulated several topical jumping off points for further investigation in books, journals, and Internet sites.

With a topic such as Greek Architecture, you will probably use more articles than books to get your information. However, check the

library catalog, using the keywords for a subject search and the names of any experts you came across for a search by author (to see if your library has any books written by these experts).

Searching on the Internet: Search engines, simple and advanced searching

Searches on the World Wide Web are mostly conducted by powerful computer programs called search engines. You might picture search engines as largely automated web surfers who jot down notes about what they find and create directories of terms to associate with each site they visit. Unlike the human surfer, these engines roam continuously following links from one site to another. The information out there on the World Wide Web is vast and search engines have visited most sites.

Why small Yahoo! continues to be so popular

For some time in the early days of search engines, the prideful boast was size: the more sites an engine had indexed the better the engine. But as the web grew and the search engine indexes grew it became common to submit a search term and get tens of thousands of returns. Too many "matches" is almost as bad as no matches. All engines have begun to offer features that let the user tame the search.

The vastness of the web explains why one of the first of the search engines remains one of the most popular. Yahoo! (http://www.yahoo.com) is an index site. What it "knows about" is far less than what a behemoth like AltaVista "knows about," but what Yahoo! can boast is that somebody—a human—has added a critical element to the Yahoo! finds: the finds are indexed. At Yahoo! you can enter search terms and get returns, but you can also follow the hierarchy of the Yahoo! index to find the subject or subjects you want. For art

historians, the first Yahoo! category is the place: Arts and Humanities. Click on that topic and a host of subcategories opens up, including Art History, Artists, Humanities, Museums/Galleries/ Centers, and others. Open one of those, let's say Artists, and another group of subcategories appears. One of them, Masters@, is where you would click to find names of famous artists from the past and present. What you find indexed at Yahoo! may be only the tip of the web iceberg, but it is a rational way to locate a few sites as starting places. And since many sites offer additional links to other related sites, this first plunge can be a very useful one.

Using multiple search engines and doing advanced searching

While there are literally hundreds of search engines, most people agree that the web is dominated by seven engines. Rather than listing each here, the reader is advised to go to a special search engine evaluation site, Search Engine Watch, http://www.searchenginewatch.com/facts/ major.html for a comparative view of the major players and for a look at some of the lesser players.

Since almost anyone surfing the web is doing so from Netscape or from Internet Explorer, one of the easiest ways to get to know the major search engines is to click on the *Search* button at the top of Internet Explorer or Netscape Communicator or from Netscape Navigator's pull-down *Directory* (choose *Internet Search*). From those places you can specify search terms and choose a search engine from among those offered (most of the big seven) by the browser.

A good way to get to know how well you get along with different search engines is to use a so-called *metasearch* program, a program that searches not the web but the returns from search engines. A good example of a metasearch program is dogpile, http://www.dogpile.com Such a program sends your search term to several search engines at once and then returns the results to you. These returns will be broken down by search engine name and so you can fairly quickly get a good idea of which engine is likely to give you the most or the most manageable returns.

The search engine market is huge and competitive (they derive most of their income from people clicking on the little banner ads that

appear—ads that often reflect something about the term you have submitted for search). Each engine will be as helpful as possible in helping you exploit its features. When you test drive a search engine it is a good idea to go to their help section where they will tell you how to use wildcards and Boolean expressions to help control the way the engine returns results to you. For example, the ability to tell AltaVista that you want *Parthenon* but not *restaurant* (+Parthenon-restaurant) will cut out a lot of sites that are useless to the investigator of the Greek architectural monument. Also, the ability to submit *Partheno** will let the engine return finds of both *Parthenon* and *Parthenos* (as in Athena Parthenos) to you.

There is a great variety of ways to limit your search. Unfortunately, the variety is from one engine to another. They do not all use the same words or symbols. But each will have an "advanced search" feature or help section that will help you find the limitations available and how to invoke them. With a little practice you'll be narrowing your hits from thousands to scores by such expressions **as parthenon | (acropolis temple)+athens-restaurant-club-cafe-shop**.

If you do a little reading in the help section of AltaVista you will discover that you may employ certain anchor words in your search. For example, let's say that you have explored the grandfather of all classical sites, the Perseus Project. You are pretty sure that any self-respecting site dealing with classical archeology will have a link to the Perseus project. You could enter the following in the AltaVista search box *link:http://www.perseus.tufts.edu/+Parthenon*, a search phrase that says, in plain English, that you want to see sites that contain a link to the Perseus Project home page AND also have the word *Parthenon*. The return is a fairly focused one.

Search engines that support image tag searching

Another tag that AltaVista supports is the anchor word *image*. If you enter into the search box the phrase *image: Parthenon*, you will have returned to you pages that have images with the file name Parthenon (as in parthenon.jpg or parthenon.gif). Understand that this simply means that the image's file name is Parthenon. If a picture of the

Parthenon had the name pic123, the search would not return that. Still, it is quite impressive the number of times an image file gets named by the name of what it represents.

An increasing number of engines offer image search capabilities. These will be especially appealing if you are looking for images of a particular monument. Once again, our giant friend, AltaVista, has been a leader in this effort to begin to make images searchable. Go to http://image.altavista.com/and enter a search term, let's say Mona Lisa. You'll get lots of thumbnail images with links to the original site. Some of the images will be pictures of the famous painting, others will show crowds standing in front of the painting in the Louvre (good for giving you an idea of the size of the painting), a few will show Mona Lisa copies and take-offs by modern artists (doing a paper on the Mona Lisa as a cultural icon?), and some will show you the Mona Lisa in commercial contexts (doing a paper on the Mona Lisa and popular culture?).

Lycos Picture and Sound, http://www.lycos.com/picturethis/ offers links to images, but without the thumbnail images. ScourNet, http://scour.net/offers itself as a multimedia site and, sure enough, a search for Mona Lisa will bring you not only a lot of images but such related items as the Nat King Cole song (again, useful if your paper is on Mona Lisa and pop culture!). Yahoo! also has an "Image Surfer." Enter your search term, let Yahoo! do its text search and then at the bottom of the return page click on Image Surfer. If Yahoo! knows of an image that matches your search term (such as *Mona Lisa*), it will return thumbnail images that can be clicked to go to the original source.

▼ Browsing while searching (open in new window)

When you have a page of links returned by any search engine you can spend a lot of time opening each link, estimating its value to you, taking notes or copying from the site, and then returning to your search engine return page and clicking on another, going through the same process, and then going to yet another search find. Depending on the power of your computer, you can probably open more than one browser window at a time. If this is the case with the computer you are using, rather than simply clicking on the link as you normally would,

right click on the link. The right click will bring up some options, one of which is "Open in New Window." Click that option and a new browser window will open and begin loading the link. Return to your first window and follow the same procedure with another link you want to investigate. By the time you have done this procedure with three or four links, the first link on which you opened a new window would be fully loaded. Now you can quickly go through the first opened sites while the later ones are still loading. By having several pages loading at once you cut down on your wait time. When you have examined an opened site and decided what to do with it, be sure to close the browser window. This returns resources to your computer and has no effect on the other open windows.

▼ Watch for upgrades

Part of the competition among search engines is seen in the add-ons they are offering. These are small programs that reside on your computer and "interact" with the search engine. AltaVista's Discovery is a good example. With the add-on active you can be reading a page that is particularly useful and at a click of the mouse send Discovery out to find what AltaVista regards as similar pages or ask the add-on to find all pages that have links to the page you are reading. You can also ask the add-on to look through the current site and make a list of sites to which the current site links.

▼ What if there is no match for your request

- You may have misspelled one or more words.
- You may have used the wrong symbols or phrasing for that particular search engine. Check the directions or helpline.
- You may have submitted too narrow a search. Try generalizing a bit—for example change the phrase "parthenon metope" to partenon metope or sculpture.

- Give the abbreviation and the full name, linked by *or: CIA or Central Intelligence Agency.*
- The information may be at a location that is either down or experiencing heavy usage; try later.
- Your computer server may be experiencing a slow-down—again due to heavy usage; try later.

▼ What if you get too many listings?

- Take a look at the first 10 to see if they coincide at all with your topic. For instance, if your inquiry on the Chrysler Building yielded thousands of articles, and the first 10 are all about cars, you'll need to rephrase the search string to exclude cars.
- If the first 10 listings *are* on your topic, download a few of them to skim offline, and extract more search terms to use.
- Add more words to your search string. Try putting a more specific word first:

> "William Van Alen"+architect+"Chrysler Buidling"+"New York"+"Art Deco"+design

When possible, link (+) the terms so that all will appear in your selected documents.

▼ Assessment questions

If you encounter an author or title repeatedly as you research among scholarly publications, you'll have an indication of which authorities are the most respected. On the other hand, the number of accessions (or "hits") of a particular Website will indicate its popularity, but what is hot is not necessarily the most reliable. You will always need to assess the quality of the information.

Note the Internet address of the source. Is it commercial? That may
not be inappropriate in itself, but just as there is a difference between
magazines and scholarly journals, there is a difference between a
document on a commercial Website and a paper posted by an
educational, governmental, or nonprofit organization. Be prepared to
get additional evidence or support.

Some of the most useful sites to the art history student will be sites
maintained by art history scholars. Scholars offer two kinds of help on
their websites. The slowest to appear but in the end the most valuable are
research projects that reside on the web. For example, Prof. Egon
Verheyen's site at George Mason University, http://www.gmu.edu/
robinson/ev.html, has a project on the history of architecture on that
campus. In addition to gathering solid information on the history of
architecture on the George Mason campus, a fairly narrow topic, the
project is also an exercise in "how to read architecture," a fundamental
issue for any art history student. There is also indication that Verheyen is
working on another web-based project on Thomas Jefferson in Europe.
This is an excellent example of a site under construction by a well-
respected scholar and thinker in art history.

An interesting and scholarly site on the wood engraver Thomas
Bewick is Roger H. Boulet's Edmonton Art Gallery site at
http://199.185.138.2/bewick/default.html. The site has a brief biography of
the artist, a discussion of his body of work, and a bibliography.

Prof. Stephen Murray's (Columbia University) Amiens Cathedral
Project is much more than just a scholarly site devoted to the cathedral
(http://www.learn.columbia.edu/Mcahweb/index-frame.html). It is evolving
into a true multimedia experience that even over the Internet offers the kind
of interactive contact that one has come to associate with CD-ROMs.

The number of sites such as these is growing and will continue to
grow. Eventually there will be an index. In the meantime, how do you
find them? First, as you do searches be on the lookout for returns that
point to sites whose addresses end in .edu (education) or .org (where
many museums are located). Second, try some searches in which you
specify that specific terms must be found on the site. Let's say you are
doing research on Michelangelo, you could specify: +Michelangelo+
art+history+university; or simply: +Michelangelo+university. Third,
when you find one scholarly source, see if it has links to related sites or
e-mail the person responsible for the site and ask them if they can
recommend other sites.

A second kind of site that scholars are providing us with is the "link review site." When a scholar and teacher such as Prof. P.E. Michelli at St. Olaf College provides links to Internet resources in art history and professional issues surrounding art history, http://www.stolaf.edu/people/michelli/index1.html, you have a list of sites which (unlike those returned by a search engine) have been reviewed, commented on, and made more reliable because a trusted teacher of the subject has listed them for her students and for others. Sweet Briar College's Prof. of Art History, Chris Witcombe, provides a similar service on his site, http://witcombe.bcpw.sbc.edu/ARTHLinks.html. A good place to find such resources is on the member's page of the Art History Webmasters Association, http://www.er.uqam.ca/nobel/r14310/Listes/AHW-Members.html, under the direction of Prof. Robert Derome of the Art History department of the Université du Quebéc à Montréal.

As you find reliable sources on the Internet and gather information about your topic, you still have the task of deciding which resources are apt to help you move your research project toward completion and which might need to put aside for different project at another time. List the categories for the information you have accumulated. Arrange a simple outline (or a topic "tree" with subtopic "branches"). Consider how topics could be further subdivided. Note the names of experts or areas you want to pursue—and those you want to drop. Finally, what conclusions does the information suggest?

After reviewing your notes, do some freewriting to see if you can identify the main points and where the holes in facts and the gaps in reasoning are. Rarely is one search session adequate, even for a short research project. Follow up on the subtopics or expert names in the same search engines or databases you were using.

 ## Searching the Internet for other sources

Home pages of colleges and universities

More and more college faculty use the Internet as part of their courses. Through the searching techniques already described, you may have already encountered syllabuses or reading lists that will help you in

your research. In addition, try searching with terms from the academic course appropriate to your topic.

Websites of governmental and other nonprofit organizations

Check the directories (pp. 57-59) or search engines (pp. 57-59) to find Websites of organizations devoted to your subject area. Often the links will lead you to alternate sources of information. For example, National Public Radio (p. 00) covers many topics—current affairs, politics, the economy, science, as well as the arts. Tapes or transcripts of broadcasts are available, for a fee. Following a delay of a day or two you may listen to the broadcasts over the Internet for no charge.

Using a gopher

This is an easy way to find sites on the Internet. Gopher is a menu system, meaning that you have a list of choices to select, connecting you each time to research facilities appropriate to the subject you specify. The name is a tribute both to the mascot at the University of Minnesota where the system was developed, and to the speed of its fast retrieval ("go-for"). Type **gopher://gopher.tc.umn.edu** to start your search, then click on the libraries you are interest in.

Type in the general subject and get a list of related sites—most of which are university libraries. You then click on the one you want and go directly to it.

Note that the gopher is a simple, nongraphic searcher. This means that it often can get results faster than the search engines because it bypasses complex graphics, but this also means it will miss many sites on the Web. It is, however, a faster way to find research libraries, and a favorite among people using a slow modem.

Using Telnet

Telnet is an established method of communicating on the Internet, but unlike the other older methods, it hasn't been replaced by other functions on the World Wide Web. At this writing, many libraries and usergroups are only available through Telnet, so you may find that you have to tackle this technology. Basically, it is the protocol (system of computer rules and formats) that allows you to communicate directly

with another, distant computer. The technology allows your keyboard to behave as if it were attached to the other computer and its programs.

For Mac and Windows users, using Telnet, which is UNIX based, is not easy. Not only is the mouse useless, touching it can sometimes even break the connection. Also, keystrokes may produce very different results from what the label on the key says. For example, an arrow key may add an unremovable symbol. If your library or computer lab does not provide detailed written instructions, ask a librarian or technical staff member for help.

First, determine if you have Telnet on your system. (Colleges with UNIX do; other systems—including commercial online servers—may require that you install additional software.)

Get the Telnet address. You usually encounter one when you're on a Website and want to go further, but you may also find what you want at **http://www.einet.net/.** Write down the address and also the *exact* letters of the **logon** (letters that you type in to start the program)—usually a word in all capitals. You may also be given a password and the **logoff** (letters that you type to exit the program).

At the prompt line or the Telnet window of your program, type in the address—the name of the organization or a series of numbers, like a phone number, separated by periods.

When you reach the site, you'll first be conscious of its simple look—just plain typeface. You may need to adjust the screen size; check the top of the screen for Options. Read the initial directions and write down (if one is given) the **escape character**—usually three keyboard symbols, such as +++, that you must use when you give commands at this site. If you don't have it already, write down the logoff to type in for the end of your session.

Type in the required logon, and follow scrupulously the directions on the screen. Don't touch any keys until you are instructed to do so. Be sure to type slowly, allowing for the brief time lag it takes for your keystroke to communicate with the other computer. If you make a mistake in typing, you can either Backspace/Delete to fix it or press Enter/Return and usually the program will allow you to retype.

Be sure to logoff once you have finished. If you are not told how to logoff, try typing {1}QUIT.

To solve some common Telnet problems, try the following approaches:

- If the site asks you what kind of terminal you have, try pressing Enter/Return. If the site repeats the question, try

entering *VT100* (the most common terminal type) according to the directions on the screen.

- If you forget the logoff or it doesn't seem to work, press */]/* or *Q*.
- Type *?* or *H* for help.

Using e-mail

Newsgroups (Usenet)

People communicate regularly on the Internet, and some are highly knowledgeable about the subject being discussed. One way to get in on the conversation is to read the postings on a **BBS** (bulletin board server) or **newsgroup** (a forum devoted to a particular topic, on which people send in their comments by e-mail). However, for research purposes, you need to be cautious. Anyone can claim to be an authority; be prepared to check a second source to back up what you get from a newsgroup.

Although you can't expect these forums to do your research for you, you will get useful information if you select your group well. Be sure to allow enough time to follow a discussion over several weeks.

You may have heard of real time conversations (live chat) on the Internet. The online services organize a number of chat rooms on various topics; see page 00 for addresses for others.

The fastest way to get information from news groups is to use **Dejanews Research Service (http://www.dejanews.com)**, which allows you to search for a specific topic (thread) previously discussed in all newsgroups—or those you specify. This way you don't have to wait for e-mail, and you don't have to search the archives of the individual newsgroups. **Dejanews** allows for quite a sophisticated query, so you can specify dates or even the university addresses of those who post. The service also gives good advice on how to conduct a search.

The only drawback is that **Dejanews** lists results in reverse chronology (the latest is listed first), so although you get the best match for your search terms on the top of the list, you are reading answers to earlier communications (which you haven't read yet). Nevertheless, this is a more efficient way to track down information from this source—rather than searching through the archives of each newsgroup one at a time.

Mailing lists (Listserv)

If you have a long-term research project, you may decide to join a mailing list where you can get all the group's messages sent to your e-mail address.

There are organized mailing lists on almost any topic. You can join one of these e-mail conferences by merely sending a message to the organizer.

Be careful: You may get a flood of e-mail. Select your list carefully and cancel when you are no longer interested.

First, select a list. You can search a list of descriptions and addresses at:

http://www.liszt.com

or

http://tile.net/lists

There are two types of lists: moderated (where a person or committee selects which messages will be posted to the group) and unmoderated (where the computer sends all messages out to the group, regardless of content). Some groups also sort messages by content (threads), so you can read only those messages that interest you.

If your e-mail program doesn't subscribe you automatically, you'll need to print out and save the directions to subscribe and (most important) to unsubscribe. **Listsev** is the program which manages the subscription to mailing lists.

Note: There are always two addresses—one to subscribe or unsubscribe (the address with *serv* in it), and one to address messages to the group (usually *group@its address*). Don't confuse the two. Because computers dumbly process your e-mail message, it's as useless to tell the whole group of subscribers to unsubscribe you as it is to give your remarks on an important topic to the computer that is composing the subscription list.

Submit a request to subscribe by sending an e-mail message according to the directions. If you can, specify a summary or digest form. (The directions will tell you if that is possible; often you specify

that only after you are already a subscriber.) The digest form means that you'll get summaries of the messages—an advantage when there are many responses each day, as there sometimes are.

When you're finished with your project, be sure to unsubscribe, sending the appropriate message, as given in the initial directions.

Query by e-mail

You may already have enough information to sift through, but often a direct question to a person can be the fastest way to get a good perspective on your topic. You might want to try a direct question to a known expert in the area of your research. To discover Internet addresses for the names of people encountered in your research whom you'd like to interview, consult one of the Internet directories (see pp. 00-00). Of course, many individuals don't answer "cold calls" queries, but a respectful, carefully phrased, and intelligent question might yield a response.

General advice for e-mail

You may get answers to your questions by reviewing the FAQs (Frequently Asked Questions) or the **archives** (previous messages or postings sent), available through Dejanews (p. 58) or listed when you subscribe. Be sure to read both for a few days before sending an e-mail query yourself. You'll invite negative responses if you ask a question that is redundant or inappropriate. Since some mailing lists are really scholarly conferences by e-mail, check carefully before attempting to participate.

As you scroll through a list of messages in a newsgroup, you'll notice the importance of accurate wording for the subject line. A well-phrased subject line assures that the message will be read by people who are interested in that topic. Many people ignore messages with vague or emotional subject lines (such as "I need help!"). Give a concise indication of your message: "request anecdotes on art history term papers."

You will also notice that some people repeat the entire message they're responding to, since some e-mail programs make it easy to do so. It's preferable to quote briefly from the message you're responding to, using an angle bracket (>) on each line to indicate the quote. Some e-mail programs do this automatically. In addition, avoid sending

 ## Knowing when to stop your search

The problem most researchers encounter is in gauging how much time to allow for the search and for the report. One thing you can count on is that writing the report almost always will take much longer than you expect. Since with computers you can write and research intermittently, add your thoughts as you assemble the notes from your electronic sources. Allow time for reflection—and for additional research if you discover gaps in your information. One of the keys to effective use of electronic resources is the efficient organization of your materials, the topic of our next chapter.

C H A P T E R **4**

Organizing Your Electronic Research Materials

▼ Starting your own digital archive

As you collect materials for your research project you will need to decide early on whether the computer will be the place you gather together everything or whether your primary gathering and organizing place will be traditional paper, index cards, etc. Some people will always feel more comfortable having the tactile presence of slips of paper as their primary research and writing materials. These people will print out everything they find on the Internet or elsewhere and join it to notes scribbled on paper or cards that they have taken from books and journals.

On the other hand, there is a lot to be said for surrendering to the computer. For one thing, most people will produce their final project on a word processor—the computer—and given the way the modern word processor operates it makes a lot of sense to maximize the computer relationships that can be forged among different parts of your research process. Keeping your notes in the word processor, having parts of web pages that you have downloaded in files on the computer, having your bibliography on the computer, and having digital images

that you might want to incorporate into the paper, means that when the time comes to draw everything together, everything is in one place.

There are some tips for making the computer your slave:

▼ Use bookmarks!

Learn to use bookmarks efficiently in your web browser. As you know, if you are looking at a web page you can push a button—sometimes called *bookmarks*, sometimes called *favorites*—at the top of your browser and the browser records the title and address of the page. The next time you want to visit the page you "pull down" your bookmarks and click on the page title you want to revisit and the browser goes out and connects again to the site.

Bookmarks are easy to use until the number gets up around fifty. Then when you pull down your bookmarks you have a long list and have to search through the list to find just the one you want. However, all browsers permit you to create folders and folders-within-folders for your bookmarks. Organizing your bookmarks makes it easier to locate something that you know you once marked. How you organize your bookmarks depends on how you plan to use them. Generally, it is a good idea to create a task folder, let's say you call it *Term paper*, and then within *Term Paper* to create subfolders such as *Good Links List, Scholarly Essays, Picture Sources*, etc., so that you can easily guess where the address is located days or even weeks after you marked the site. Your browser will also permit you to reorganize your bookmarks. You can begin with a relatively simple scheme and subdivide and rearrange as it becomes more and more populated.

▼ Text materials

If you are consolidating your research and writing materials on the computer, you will have several kinds of text: notes taken from print and other sources, bibliographic information, drafts of your paper, and probably some e-mail messages related to your work.

Insofar as possible, keep all text in compatible (moveable from one place to another) environments. Usually your operating system—Mac or Windows—will help you accomplish this need for compatibility. You are likely to run into problems only if you do some of your work in a DOS-based system and other parts of your work in a Windows environment (older programs, including earlier versions of such favorites as Microsoft Word and WordPerfect ran under DOS).

It probably makes good sense to keep project materials together in the same way as was described for handling bookmarks in the web browser. Create a project folder to hold materials and create folders within that folder as the population of documents increases to the point where order demands additional subdivisions.

Some people will prefer to keep all notes in one large word processor document while others prefer to store notes in several topical documents. Either way will work fine. Word processor search mechanisms are quick, even with large documents, so finding a keyword that will take you to the note or notes you need is usually easy. You can also easily search across a group of documents for those that contain a certain word or phrase.

The **bibliography** is a special situation. Does one keep bibliographic references with notes or in a special bibliography file? Most likely, the old practice of keeping a complete bibliographic reference file with a shorthand notation for each reference in your notes is the best procedure. More and more scholars employ some kind of specialized bibliographic software to store their records. The advantage of this kind of software is that it usually permits one to store information in discreet categories (author, title, year, place, etc.) and then produce both foot or end notes and bibliographies in any of a number of different styles (such as MLA style, Chicago Manual style, etc.). It also usually permits one to tag each entry with keywords of your own and then to retrieve items by one or more of those keywords. Some of the programs also interface, usually be means of another piece of software, with library card catalogues that conform to the Z39.50 client/server protocol and thereby permit virtually automatic grabbing of bibliographic information directly from the online catalog (see Steve Osborn's page at the School of Library & Information Science of Indiana University-Purdue University at Indianapolis, http://php.iupui.edu/~rsosborn/Scholars_Quest/References/Gathering/ Reference_Tools/BibliographicSoftware.html for a review of these products).

Some word processors have built-in bibliographic "wizards" that help one construct notes and bibliographies. Some people prefer to keep their bibliographies in some kind of spreadsheet or relational database. The advantage of custom bibliographic software, whether bought or designed by you in your own database program, is that your gathering form will have blanks for all the kinds of information that a **complete** bibliographic reference needs. If you have a blank before you, you are less likely to forget to include a key piece of information, such as year of publication, than if you are just typing in information on a word processor blank screen. But, again, if you decide to mechanize the bibliographic process, be sure that you go with something that is fully compatible with your word processor. Ideally, you should be able to generate an entry or entries and have the program insert them directly into the paper you are writing on your word processor.

(See Chapter 5 for questions of bibliographic and citation style)

E-mail messages can usually be saved as plain text or as html (web page style), depending on how they were composed and how they were received by the program that you use to read your e-mail. Either version is often a messy-looking thing. E-mail messages that quote from earlier e-mail messages usually indicate the quoted portions by some kind of indention and it is not unusual for a message to be saved with a very ragged left and right margin. Add to the quoting convention the fact that how a message looks to the sender is not necessarily how the message looks to the receiver (a slight difference in how the sender program and received program interpret word wrap and the received version may well be made up long lines alternating with extremely short lines). It is probably a good idea to keep the "pure extract" of an e-mail message somewhere in your archive. However, when you are quoting from an e-mail message in a piece of scholarly writing be sure to check the formatting so that the message reads smoothly—either as simply a short quotation or as indented text for longer messages.

Images

Art history centers on images, and often images of images. We hope that we are talking about original works of art, but almost always do so through the agency of photographic reproduction. Increasingly, the

photographic medium is the digital image—and the digital image is as much at home in the computer archive as is text (and, for that matter, so too the digital sound recording and the digital movie). Just as you collect notes taken from web pages and other sources and file them away to be used later, and just as you carefully take down complete bibliographic information on written materials, you will almost inevitably save images, perhaps even using some of the images in your final paper.

Here we must digress from the practical matter of how to store images so that you can find them when you need them to touch on the thorny issue of **copyright**. If an image that you find on the Internet or as part of any digital medium (a CD-ROM, for example) is copyrighted, then you probably do not have the right to reproduce that image ("probably," because the issue of the fair-use doctrine is still being argued in legislative bodies and in the courts). Do you have the right to keep a copy for your own study purposes? Again there is argument, but a court, if asked, might say "no." The entire issue of what one may or may not legally do with copyrighted digital materials is one that you might want to discuss with your teacher.

That said, there are places on the Internet where viewers are given permission to copy images for educational purposes or for personal use (see, for example, the policy of the Fine Arts Museum of San Francisco (personal use): http://www.famsf.org/ and the policy of the Art Images for College Teaching (educational use): http://www.mcad.edu/AICT /html/index.html). And, of course, there are some images that are regarded as being in the public domain (for example, many of the images made available by the web site of the Library of Congress). In other words, there are sample opportunities for students of art history to acquire images of art objects for their own use.

We return to the question, "how do you keep up with digital pictures?" Unlike text such as "Michelangelo was born in . . . ," which, if we have forgotten where we put it, we can ask the computer to search through files for it, we cannot tell our computer to search through files to find a picture of a marble statue of the Madonna holding the body of the crucified Jesus (in fact, such a technology is emerging). And so, if we acquire more than a few images, we had best create a system for tracking the location of the images.

The same kind of system that was suggested for organizing text and bookmarks can go a long way toward taming a digital image collection. Let's say that you have five images. You could place all five images in a

subdirectory of your file system and call the subdirectory "pictures." If you gave each image an even abbreviated descriptive name (picasso.jpg.matrisse.jpg, heckel.jpg, cezanne.jpg, rothko.jpg) you would probably be able to find the image you wanted without much trouble. And now let's say that you acquire fifty new Cezanne images. Under pictures, you would probably want to create a new subfolder called *cezanne*. And under that might want to create separate subfolders such as *portraits,selfport,stillife,lscape*, and perhaps even subdivide *portraits* into divisions by sitter's name or date.

This general scheme of filing your images in a hierarchy of folders is sensible, but even so, at some point it will become unwieldy. At some point you need to have some kind of visual access to your collection. There are some "freeware" and "shareware" programs available that can help. The freeware (you have no obligation to ever pay for using the program) come and go. Check www.sharware.com or www.download.com under the term *image* to see what is currently available. At the same sites you will find shareware, a term that describes programs that you may download and use but with the understanding that after a reasonable trial period you will pay for the program if you decide to continue using it. One of the most popular shareware image sorting programs is ThumbsPlus, also available from the company site: www.cerious.com.

How do you download an image you have found on the web? Simple. Right click on the image. You will find an option that says something like "Save picture as . . ." click on the option and either accept the default name for the file or give it a name of your own choosing. Within seconds the image is saved to your computer.

Just as you record text sources in a bibliography, you need to get in the habit of noting the source (at least the URL) of the image. A simple way to do this is to keep a log in each image subdirectory in which you note the name of the image file and then whatever "bibliographic" information you want to record about the image. But remember, if you move the image, you need to also move the information. Another advantage of using something like ThumbsPlus to keep track of your images is that you can use the program to "attach" such information to the image. If, thereafter, you use the software program to move the image, the information that you have associated with the image moves with the image file.

There are two kinds of readers of this booklet: students who are taking a single art history course and students who plan to take several

or perhaps major in art history and maybe even go on to graduate study in the subject. To this latter group a word of advice: just as you are accumulating a bibliography of written materials that will grow and grow as you continue your studies, begin accumulating images as well. These images will serve you well in your studies and will be invaluable to you if you find yourself one day teaching art history to others.

New storage media

One of the physical problems that collecting any kind of information (visual or textual) on the computer is that the material you collect takes up disk room. Even if you have your own computer with a large hard disk you will eventually fill it. Fortunately, there are ways of dealing with this problem. There is now a plethora of portable high capacity storage devices (such as "Zip" disks). These look a lot like floppy disks except that they store a great deal more information. Such media require special drives to record and read back the information. Increasingly, such drives are included as internal drives on computers for the consumer market and on machines that are installed in university computer labs. If you do not have access to a machine with an internal high-capacity portable disk, you can purchase portable disk drives that are relatively easy to use by moving them from machine to machine.

Can a computer lose everything I've collected and written

Yes. What's more, if you keep all of your materials on one and only one hard drive, you **will** eventually lose it. All disks eventually fail. Teachers are discovering that most hard disk crashes occur the night before a research paper is due in class. Protect yourself against the certain, eventual failure of your computer hard drive by routinely copying all of your documents to another disk or disks. Every computer operating system comes with some kind of backup routine. Use it. As your project reaches its end, you probably will want to print

final drafts of your paper so that you can see what it looks like on paper—the medium in which your teacher is most likely to read it. A by-product of these printed versions is that you also have a hard copy of your work as it nears completion. If the disk crashes, at least you have a paper copy to reconstruct with, even if you have to retype the paper on another computer!

Take advantage of new electronic tools that work while you sleep

If you have your own computer and your own access to the Internet, you can do several things to have the computer work for you even when you are not sitting at the keyboard. We discussed bookmarks (or "favorites") above. Both of the major web browsers (Netscape and Microsoft's Internet Explorer) offer advanced features in their bookmark functions. When you next bookmark an Internet site, take a look at the options offered to you. You can choose to simply record the name and address of the site. But you can also specify that you want the browser to periodically check on the site to see if it has changed and if it has to notify you (usually by placing a special symbol next to the name in the bookmark list) that the site has changed. You can also specify that if a change to a site is found that you want the browser to go ahead and download the page so that you have the page on your hard drive and do not have to wait in front of the monitor for the page to download so that you can examine what has changed. If there is a site that is especially valuable to you—let's say one that tries to list new sites on a particular topic as they appear on the web—you might want to use one of the advanced bookmarking features when you add the site to your list. This might also be an apt thing to do to your class web site if your teacher maintains one! To take maximum advantage of this function you need to leave your computer on all the time and have it connected to the Internet.

Some sites, mostly large commercial ones, offer a free subscription service. Often called a "channel subscription," this option relies on the site itself to notify your computer that the site has been updated. In addition to the commercial sites, some scholarly sites also offer the

same service. Normally, if a site offers this service it will say so in a prominent place at the beginning of the site.

Personal "spiders" or "agents" are software programs that follow your instructions for examining and downloading the pages of a web site to your hard drive. NetAttache Pro(http://www.tympani.com/) and Webwacker (http:www.bluesquirrel.com/products/ whacker/ whacker.html) and are two of the most versatile and popular. For the art history researcher these tools are especially helpful when you find an image-rich site that you wish to examine in detail. You could spend hours following all of the image links of the famous Farm Security Administration photographs on the Library of Congress site. On the other hand, you could launch a personal agent to visit and download the pages while you are away from your computer and then quickly look at the results at a later time—quickly because the page would have been recorded to your own machine. Looking at the site's web pages is as fast as looking at anything else that resides on your computer rather than on a distant Internet site.

We discussed visiting online catalogues of libraries in chapter 3. More and more libraries have online catalogues that follow what is called the Z39.50 protocol. In practical terms this means that they follow an agreed-upon way of coding basic catalogue information such as author, title, and subject. Software is now available that takes advantage of this protocol. You can launch the software to search one, several, or hundreds of online library catalogues all over the world. The finds of these searches are stored on your machine. While it might take many minutes or even hours for the software to complete its work, the results are available to you for quick perusal, sorting, collapsing into narrower subject terms, or isolating by library. Steve Osborne, "Bibliographies Software: Guides & Resources" <http://php.iupui.edu/ ~rsosborn/Scholars_Quest/References/Gathering/Reference_Tools/Bib soft-Guides&Resources.html>, has a review of several of these programs. BookWhere?2000 (http://www.bookwhere.com/) is a very sophisticated example of such software and offers a trial version that is limited to fifty returns on any search. The full version offers unlimited returns.

5

Reporting Your Research

▼ ## Fair use and the copyright law

Provide the source for every idea or fact

The material you find electronically was put there by someone, and you are legally and morally required to give appropriate credit—just as you do for other sources of information. You will notice on many Websites a line from the author granting permission to reproduce the material for personal use—but you still have to give that author credit. And, in fact, you want the authority of the source as support for the quality of your research and the legitimacy of your conclusions. As with print sources, give as complete a description as you can, so the reader of your paper can consult your sources firsthand if desired. Withstand the temptation to keep huge chunks of material that you found in their original form. It is tempting—particularly because everything is already typed! Know that the penalty for plagiarism is severe (failure of the course or expulsion from college), and you're likely to be discovered, since your instructor has the same Internet access as you. Some instructors, in fact, are now requiring their

students to print all their sources of information and submit them with their paper.

Be sure that your thoughts dominate the report. Your paper is your interpretation of what you have found—supported by the facts and opinions you cite. In other words, don't just string your findings together without reacting to the information: Analyze and interpret the data, in a logical format, according to your sense of the most important points. Make certain that you place quotation marks around any phrases taken from another person's writing or speech, and tell where you got those phrases.

Follow the correct format

Your teacher will probably specify a format (or formal writing "style") that he or she prefers for research papers. Some general style rules are generally applicable to all writing (things like double spacing the essay, leaving at least a half-inch margin all around, using standard bond paper for the final output). However, on the specifics of citations—footnotes or endnotes and bibliography—quite a number of styles exist. Most of these styles have evolved within specific academic disciplines and reflect a consensus within the discipline about how best to make clear to the reader the source of information. Clarity of communication lies at the root of all citation style.

For American writers in art history the closest thing the discipline has to a set style is that put forward by the College Art Association in its *Art Bulletin* style specifications. The *Ab* style sheet can be found at the CAA website at: http://www.collegeart.org/caa/publications/AB/ABStyleGuide.html (address also available at the website).

The CAA specifies that for general questions of style, the writer should consult the *Chicago Manual of Style*, 14th edition, with the *MLA Handbook for Writers of Research Papers*, 3rd edition, a second choice. For spelling, CAA specifies *Webster's Third New International Dictionary* or *Webster's New Collegiate Dictionary*. In addition to these general reference works, the CAA style has specific instructions on how they prefer to see writers handle such things as references to the Bible and references to classic works that may exist in numerous editions. Should your teacher require the CAA style, you should consult the website specified above in conjunction with whatever other style manual may be recommended by either your teacher of the CAA.

At the time this guide was printed the CAA had not yet supplied specific requirements for electronic resources. However, following their deferral to the Chicago Manual or the MLA Guide, the following formats for references to electronic materials represent sound practice. Again, you should probably consult with your teacher before making your citation style final.

Overview of the standard citation format

The CAA prefers that complete reference information be included in the first note which references a work. The preferred CAA style is to indicate a note by a superscript number (these must be sequential from first to last) placed after punctuation and then a list of notes placed at the end of the essay which conform to the sequence in the text. The general format for a book is

> note number
> period
> author
> comma
> title of book (either underlined or italicized)
> comma
> left parenthesis
> city of publication
> colon
> name of publisher
> comma
> year published
> right parenthesis
> comma
> page number(s) within referenced work
> period.

This would result in an entry (let us say it is note number 4) that looks like this:

4. Hans Jantzen, *High Gothic:The Classic Cathedrals of Chartres, Reims, Amiens*, (New York: Pantheon Books, 1962), 110-12.

Notice that the number of the note is not superscripted (i.e. it is not printed high on the line of text) in the notes themselves. A second note by the same author and book should appear in a shortened version, as in

> 12. Jantzen, 125.

A note referencing a journal article takes the form:

> note number
> period
> author
> comma
> left quotation mark
> title of article
> comma
> right quotation mark
> title of journal (either underlined or italicized)
> journal volume number
> left parenthesis
> year of publication
> right parenthesis
> colon
> page number(s) referenced
> period.

An example would look like this:

> 3. James Elkins, "Art History and Images That Are Not Art," *Art Bulletin* 77 (1965): 555.

Once again, a second reference to the same article would appear in shortened form.

According to CAA practice, one might not need a bibliography (CAA calls for a bibliographic list only for "frequently cited sources.") You will need to check with the requirements of your class project to see whether a bibliography in addition to notes is required. In general, listings in a bibliography follow the same general form with these exceptions: first, the author's last name appears at the beginning of the entry, followed by a comma and the first name. Second, page numbers

do not appear as part of a book bibliographic reference and the page numbers that accompany a journal article should specify the page numbers of the journal that include the entire article, not just the part or parts that you referred to in your paper.

References to electronic publications should try to follow the general format for either book titles or journal titles shown above. Adjustments are made for the specifics of how one locates material and for the peculiarities of a specific title (CD-ROM publications, for example, often being "team" efforts, do not always have an author; a website may or may not have an identifiable author or date of "publication"). Some representative examples follow.

CD-ROM or Stand-alone database

> Brooklyn Museum, "Glass," *Ancient Egyptian Art: the Brooklyn Museum*, CD-ROM, (Alameda, California: Digital Collections, 1997).

In the above example we notice that there is no page number. The closest we can get to giving the reader a precise location for the material that we referred to is on a section about "glass."

> Pauline Kael, "Pauline Kael Review: West Side Story," *I Lost It at the Movies, Cinemania 96*, CD-ROM, (Microsoft corporation, 1996).

Here we have an author, Pauline Kael, and a book title (*I Lost It at the Movies*) with the entire book included on the larger CD-ROM which has its own title (*Cinemania 96*). The meaning of the citation would probably be evident to anybody familiar with the fact that Pauline Kael edited some of her film reviews in a collection called *I Lost It at the Movies* and also knows of the Microsoft compendium on CD-ROM. Practice is fluid enough that if one wanted to include the phrase "included in" (or "on") or simply "in" between the title of the Kael book and the title of the Microsoft CD-ROM, that would be fine.

An online website

Depending on what you are citing, you may decide that your online reference is the equivalent of a book or more similar to an article. In either case, you want to provide as much standard citation information

as you can, along with aids that will permit your reader to find your source. Let us dissect the following reference:

> Washington Allston, *Lectures on Art, and Poems*, (New York: Baker and Scribner, 1850) 22 <http://www.umdl.umich.edu/cgi-bin/moa/viewitem.stable/mm000110/17261ect/v0000/i000/00340022.tif?config=moa&userID=NoUserID&dpi=4&nav=First%20Page%3Dmm000110%2F17261ect%2Fv0000%2Fi000%2F0001r001.tif,Table%20of%20Contents%3Dmm000110%2F17261ect%2Fv0000%2Fi000%2F0009r009.tif,Title%20Page%3Dmm000110%2F17261ect%2Fv0000%2Fi000%2F0001r001.tif&main=&cite=%2Fcgi-bin%2Fmoa%2Fsgml%2Fmoa-idx%3Fnotisid%3D>. February 3, 1999. Lkd. *Making of America*<http://www.umdl.umich.edu/moa/ >. February 3, 1999.

Here our source is a printed book that has been made available on a website specializing in social and cultural sources of American history. Notice that we began with a standard bibliographic reference because the scholarly website provided precise information on the original publication. That information is followed by the very long URL that got us to page 22 of the web reproduction of Allston's book. Please notice that the URL is included within brackets. This practice, now almost universal, makes clear to the reader that the URL begins immediately after the left bracket and ends immediately before the right bracket, a way of setting off the URL so that the reader does not make the mistake of trying to include, for example, the period at the end of the URL. Such an erroneous inclusion might be enough to prevent your reader from locating the site.

Notice also the abbreviation *Lkd*. This stands for "linked from." The practice of using a "linked from" URL does two things. First, it adds some depth to your essay since it leads your reader to the same source on American cultural history in which you found our reference. Second, and more importantly, it also provides the cyberspace equivalent of a "permanent address." The fact is that the particular title (in this case Allston's book) might change, or the method of locating the title might be altered, and by the time your reader gets around to looking for the material the URL placed in the browser returns a "can't locate" message. The *Lkd*. reference is in part a hope that the master address of the archive will not change even if the specifics of items within the archive do change. So, if the reader can't get his or her

browser to open the Allston page, they have the information to go back
to the archive page form which you probably located the material
originally. In this particular case, the URL is so long and tedious that a
person trying to manually enter the address could easily make a
typographical error. The linked address is much easier to type.

You will also note that the reference has a fairly recent date
following each URL. This is the date on which you, the writer, viewed
the material. In part this date-visited information lends circumstantial
evidence that you actually visited the page. Again, more importantly, it
lends yet a bit more information to a person's search for the same
material. If several years pass before a reader tries to visit the site, it
may well be that the entire site has moved or disappeared. The
disappointed reader could at least contact the original location
(umich.edu) and specify that in February of 1999 your site included
this item and ask, "do you know what happened to it?"

One of the downsides of web resources is that they move without
always leaving a "forwarding address." Another problem is that the
technology used to visit the World Wide Web is always changing. In a
few years we might have greatly simplified address mechanisms for
finding material. You owe to your reader of a few years hence whatever
aid you can provide for being able to reconstruct your finding of a site.

A simple citation is usually enough for a small or personal site. For
example:

> Perette Elizabeth Michelli, "Art History with Michelli,"
> <http://www.stolaf.edu/people/michelli/index4html>.February 1,
> 1999.

This site has the author's name, title of the page, and address, plus the
date visited. Might this site disappear, with all of its good tips on
finding art history resources on the Internet? Of course. Faculty
members move and take their pages to new locations. However, with a
little detective work a reader years from now could probably figure out
that this page resided at St. Olaf College (most of the time you can just
type in that part of the address up to the first forward slash to find the
root home of a page) and we've also supplied the reader with a date on
which the page was viewed. Somebody at St. Olaf might be able to
help us find a new address for Professor Michelli should she no longer
have a page at the college.

Visual information on the web

You may make reference to a picture (or any other non-text medium) that you found on the web without reproducing the image. In general, you will want to use the same kind of format that was illustrated in the Washington Allston reference above.

> Auguste Renoir, detail of toys from *Child with Toys - Gabrielle and the Artist's Son, Jean*, 1895-1896, <http://www.nga.gov/cgi-bin/pimage?65257+0+3>. 15 February 1999. Lkd. <http://www.nga.gov>. 15 February 1999.

In this example we are drawing the reader's attention to a detail of a Renoir painting and also telling (via the Lkd.) where we were when we found the image.

E-mail message to you

Just as you may include reference to a letter mailed to you in response to a question posed to an authority in the field in which you are doing your research, you may also make reference to an e-mail message by such an authority. In fact, e-mail has so quickly become the standard medium of exchange in academia that it is likely that communication with a person at another institution will be via e-mail. The general expectation of such a reference is that it give: 1. the name of the person (usually a title or statement of expertise), 2. to whom the message was sent (usually you), and 3. the date of the message. For example:

> Young, Sally, Ph.D. (Director of Composition, University of Tennessee at Chattanooga). E-mail to the author. 13 May 1996.

Notice that the reference does not include the person's e-mail address. It is considered bad form to give out another person's e-mail address. If you have received helpful information from an authority it is considered good form to contact the person again and tell them that you want to include a reference to their earlier message before you actually include the reference.

A posting to a discussion group

E-mail-based discussion groups are available in not only broad subject areas, but in many specialized areas as well. For example, the

Consortium of Art and Architectural Historians (CAAH-L) is several
hundred art and architecture historians who exchange information on a
regular basis. There are no "period" restrictions to the group. On the
other hand, BYZANS-L caters to the needs of those involved in
Byzantine studies, whether art, literature, politics, or whatever. The
general trend has been for groups to grow to a certain point and then
split into more and more specialized subject areas.

In chapter 3 we gave some hints on finding such groups. Chances
are, your teacher may also be able to suggest groups. If you obtain
information from a submission to one of these groups, you may cite the
message as a source in your paper. An entry might look like this:

W.F. Wong, <wf@CAMELOT.DE>, "Re: Image," 16 Jan 1999,
ARCO (Art & Literature, Psychology and Communication) via
<http://maelstrom.stjohns.edu/CGI/wa.exe?A2=ind9901&L=arco&
F=&S=&P=200>. 17 January 1999.

Notice that here the author's name AND e-mail address are included
(because the sender has willingly surrendered this information by
making the post, the assumption is that the sender does not object to
the address being disseminated). The topic of the message ("Re:
Image") is given, along with the name of the group. Then the reference
notes the source where the term paper writer saw the message (in this
case, a publicly accessible archive for the ARCO group maintained at
St. John's College), and finally the date on which the message was
read by the writer of the term paper.

What if you are asked to make a web page?

It is very likely that you will be asked to make a web page or a web
site. In fact, chances are pretty good that you have created a web page
even if you did not know that you were doing it—many of the most
popular e-mail programs produce messages in the form of web pages.
If your e-mail program lets us do things like specify a type style, select
a background color, or insert an image, you are, in fact, creating e-mail
messages that are web pages.

More to the point for the art history student writing a research
paper, it is increasingly likely that your instructor will require you to
turn in your project in HTML (HyperText Markup Language)—a web
page or pages. If you have never made a web page (or think you

haven't), don't despair. Making a web page is no more difficult than making a page in a web processor. In fact, most current versions of popular word processing programs have a "Save as HTML" function. The two leading web browsers (Netscape—both Navigator Gold and Communicator—and Microsoft Internet Explorer) have page creation functions built into them. Using these functions is not very different from using a word processor. What both the word processor's "Save as HTML" function and the browser's page creation capability do is allow you to type as you would in a word processor, cut and paste material into your page, insert images, video, or sound files into the page, and although you never see it (unless you choose to view it), the programs create the HTML code "underneath." The often-complex coding is done for you, based on what you do as you work in a WYSIWYG (what you see is what you get) fashion on the screen.

Why would your teacher require you to turn in your research in web format? Quite simply, at the turn of the millennium the web page is increasingly the medium of communication of choice. We live in a world in which we are doing more and more of our communicating in a web page format. You need to know how to participate actively rather than passively in this communications revolution.

D A T A B A S E S &
S E A R C H T O O L S

Databases

Look for these in your library. They may be listed in a menu of choices
on your library's home page, or they may be installed in designated
computers. Some are also available in print, but the electronic versions
are much faster to use. Use the searching techniques described on
pages 29-31.

Indexes
Art Abstracts
Humanities Abstracts
ARTbibliographies Modern
Arts and Humanities Citation Index
Avery Index to Architectural Periodicals
Bibliography of the History of Art

SEARCH ENGINES
Lists and links to search engines
Beaucoup!, http:www.beaucoup.com/engines.html

Dr. Webster's Big Page of Search Engines,
http://www.drwebster.com/search/search.htm
Search Engines Worldwide,
http://www.twis.com/~takakuwa/search/search.html

MetaSearch machines (these run searches on multiple search engines at once)

MetaSearch, http://metasearch.com/
Internet Sleuth, http://www.isleuth.com/
ProFusion, http://profusion.ittc.ukans.edu/
Dogpile, http://www.dogpile.com./

General search engines

AltaVista, http://www.altavista.com/
Excite, http://www.excite.com/
InfoSeek, http://infoseek.go.com/
HotBot, http://www.hotbot.com/
Lycos, http://www.lycos.com/
WebCrawler, http://www.webcrawler.com/
Yahoo!, http://www.yahoo.com

Search engines with specialized tools for image and media searches

Scournet, http://www.scournet.com/
AltaVista Photo Finder, http://image.altavista.com/cgi-bin/avncgi
Yahoo! ImageSurfer, http://isurf.yahoo.com/
Excite! Photos, http://www.excite.com/photo

Search tools for discussion groups and newsgroups

Dejanews, http://www.dejanews.com/
Tile.Net, http://tile.net/lists/
Liszt, http://www.liszt.com/
ForumOne, http://www.forumone.com/
Reference.Com, http://www.reference.com/

Some interesting sites for investigation

The McGraw-Hill Art Gallery,
 http://www.mhhe.com/socscience/art/index.htm
Mother of All Art History Links Pages,
 http://www.umich.edu/~hartspc/histart/mother/

Art History Resources on the Web,
 http://witcombe.bcpw.sbc.edu/ARTHLinks.html
Computers and the History of Art,
 http://www.hart.bbk.ac.uk/chart.html
Digits: An Art History Teacher's Practical Advise and Random
 Musings on New Technologies and the Classroom,
 http://www.clt.astate.edu/wallen/digits
Art History Webmasters Association,
 http://www.er.uqam.ca/nobel/r14310/Listes/AHW-
 Members.html
The National Gallery of Art (Washington DC),
 http://www.nga.gov
Fine Arts Museums of San Francisco, http://www.famsf.org/
Art CD-ROM Reviews (part of Artchive),
 http://www.artchive.com/cdrom.htm
Art Images for College Teaching,
 http://www.mcad.edu/AICT/html/index.html
Time Lines of Art History,
 http://www.dc.infi.net/~gunther/t1001.html
The Art History Research Centre,
 http://www.fofa.concordia.ca/arth/AHRC/index.htm
The Internet as a Research Medium for Art Historians,
 http://www.fofa.concordia.ca/arth/AHRC/essay.htm
The Getty Information Institute, http://www.ahip.getty.edu/
Project Guttenberg (book texts online), http://www.promo.net/pg/
Acronyms and Abbreviations, http://www.ucc.ie/cgi-bin/acronym
The Internet Public Library, http://www.ipl.org/
The World-Wide Web Virtual Library: Electronic Journals,
 http://www.edoc.com/ejournal/
Bullfinch's Mythology Search Page,
 http://www.showgate.com/medea/bulfinch/search.html
AltaVista Translations, http://babelfish.altavista.com/

Typing Reminders

Type carefully because a mistake can take you to the wrong location or to nowhere at all. If you know you typed correctly, be aware that the Internet changes rapidly. Use the directories and search engines on pages 57-59. In general:

- Check each character before pressing Enter/Return.
- Use no spaces with Internet addresses.
- Use no period at the end (there may be a slash [/]).
- Use lowercase unless you are told that the program is "case sensitive" or you are copying an obvious capital in an Internet address.
- Use the Shift key (not the Caps Lock key) for the upper symbol on the number or punctuation keys.
- Be careful to distinguish between the letter *l* and the number *1*, the hyphen (-) and the underline (_ [which is above the hyphen]).
- The ~ symbol is the Spanish tilde, above the grave accent (`) at the top left of the keyboard.
- Slashes (//) are **forward** slashes, at the bottom right of the keyboard.
- The **Break** key is also called **Pause**; it's on the top right of the keyboard, above **PageUp**.
- On the Macintosh®, **Ctrl** is an open apple symbol and **Alt** is a filled-in apple symbol.
- Within Websites, you can click on "buttons" on the margins of the page you're looking at:
 Back takes you to the previous page.
 Forward takes you to the next page, but only after you've first moved backwards.
 Reload gets the Website back on your screen.
 Bookmark saves the address of the Website to your list (also called Favorites or Hotlist).
 Home gets you to the home page of your server—your college, library, or online service.
 History lists the sites already visited.
 Stop interrupts downloading or the attempt to reach a site, necessary during a slowdown.
 The **X** or **square** in the top right-hand corner of the screen (or top-left for Mac) allows you to exit quickly—usually returning you to your home page, but sometimes signing you off.

Index